T0193154

Girls Will Be Boys Will Be Girls Will Be...

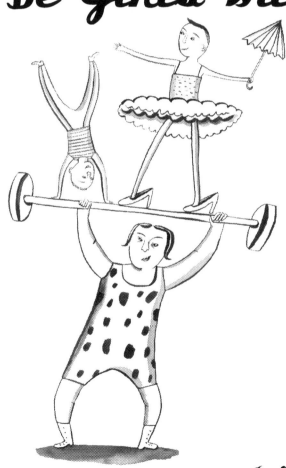

Soft Skull Press

Cover design: Joel Tippie
Cover illustration: Giselle Potter
Interior design: Joel Tippie
Printed in the United States of America

ISBN: 978-1-932360-62-2

Soft Skull Press
New York, NY

www.softskull.com

How do you define gender?

How many genders are there?

What would the world look like without gender?

In what ways do you feel confined or restricted by your assigned gender?

Was the gender assigned to you the one you feel most comfortable with?

What privileges do you or don't you have due to the gender you've been labeled?

Do you feel forced to act in certain ways because of your assigned gender?

What happens when you don't act these ways?

How do you unlearn gender?

Once upon a time, there lived two strong, compassionate, and rambunctious young people named Irit and Jacinta. These two friends spent their days swinging from ropes into sparkling lakes, digging ditches in the sand that stretched all the way to the Yangtze River Valley, choreographing dance routines to the hits of the 80's in sprakly spangles, and stacking abandoned refrigerators (without the doors, of course) to build temporary shelters for exhausted caregivers of strong, compassionate, and rambunctious young people. Jacinta and Irit always has extraordinary fun.

Although the two of them had a blast together, they tended to dabble in more elaborate projects that required the participation of other friends as well. For instance, they would spend the weekdays teaching the rest of the neighborhood young folk the aforementioned dance routines and then would all perform them on Sundays for a demanding public. People from as far as 102 blocks away would mount their bikes, trikes, scooters, skateboards, roller-skates, unicycles, and go-carts just to make it for the widely acclaimed show. Once their friends Keetin, Momo and Zuri caught wind of these shows, they would bounce their pogo sticks through fields of rhubarb and thick patches of cantaloupe just to be part of it all.

As much enjoyment as the young folk found in such gatherings, there were grown-ups who were doubtful and wary of certain aspects of the performances. Irit and Jacinta were thought to be bad influences on the boys because they taught them how to twirl and wear pink eye shadow. They were also thought to be negatively influencing the girls because they taught them how to use a power drill and construct large stages. This was very confusing to Jacinta and Irit who saw that their friends Makai and Joon were naturally skilled with power tools. And their friends Rafael and Chen did especially grand pirouettes in hot pink and mustard yellow tutus.

There were other ways in which the young people and older people were sometimes at odds with one another. One day while playing in the park, their friends Tae and Silvani decided to race to the tire swings. While running, Tae tripped over a huge watermelon right in the middle of the path, scraped his knee and began to cry. Tae's parents, immediately turning around at the sound of their son's loud cries, rushed over to the scene. When they got there, they picked him firmly off the ground and said to him, "toughen up, it's just a scrape, BOYS DON'T CRY."

Now this troubled Silvani greatly and she knew at once that she must say something.

She took a deep breath and said firmly "Excuse me, but I happen to know that it's very healthy for all people to express everyone of their emotions which means: BOYS DO CRY!!!"

It was almost as if light bulbs went on over Tae's parents' heads. They got it. They really did. They held Tae close and he cried. They thanked Silvani for her wise words. Now, Jacinta and Irit happened to be at the park that day and saw this whole scene from the top of the monkey bars. They started clapping so hard they almost lost their balance. Almost, but not quite. They later went home to organize a special celebration in honor of their personal hero of the day, Silvani. To honor her, they read a poem that seemed to help everyone feel less bogged down by the grown-ups who were trying to mold them into dainty young ladies and rugged young men. This is the poem they read:

> *For every girl who is tired of acting weak when she is strong, there is a boy who is tired of appearing strong when he feels vulnerable.*
>
> *For every girl who is tired of people not trusting her intelligence, there is a boy who is burdened with the constant expectation of knowing everything.*
>
> *For every girl who is tired of being called over-sensitive, there is a boy who is denied the right to be gentle and weep.*
>
> *For every girl who is called unfeminine when she competes, there is a boy for whom competition is the only way to prove his masculinity.*
>
> *For every girl who throws out her E-Z-Bake Oven, there is a boy who wishes to find one.*
>
> *For every girl who takes a step toward her liberation, there is a boy who finds the way to freedom has been made a little easier.* *

After reading this poem and honoring Silvani and eating carrot cake, Irit and Jacinta rested a bit because of such a long day. So, the next day when the heat was much too oppressive to dig ditches and was making their sparkly spangles stick to their tummies, Irit and Jacinta decided to take action against all the rigid gender roles that had been unwillingly placed upon them and their friends. They got out all the markers, crayons, pens, pencils, and scissors they could find and created a coloring book that would help everyone realize that it is in all our natures to be gentle, brazen, vulnerable, courageous, and emotional, no matter what gender we are. They created a coloring book that makes it perfectly sensible to color outside the lines.

*based on a poem by Nancy R. Smith

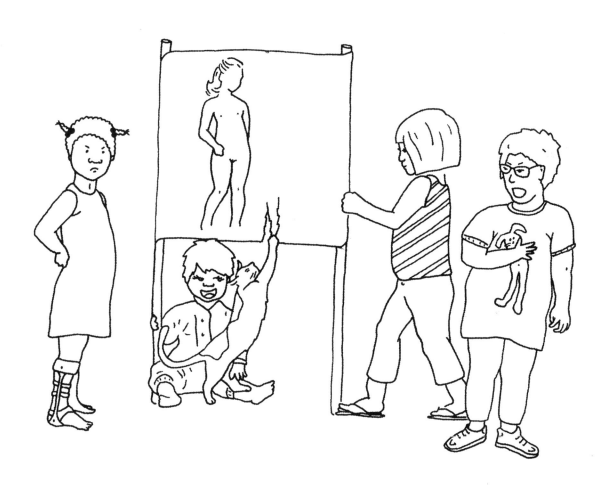

We'll decide for ourselves what girls can be.

I'm allowed to get angry!

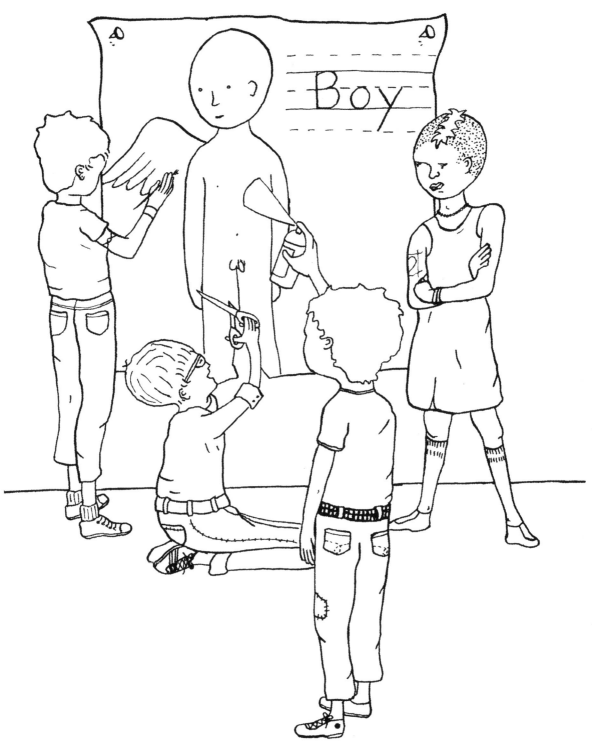

There's more to being boys than what
they told us.

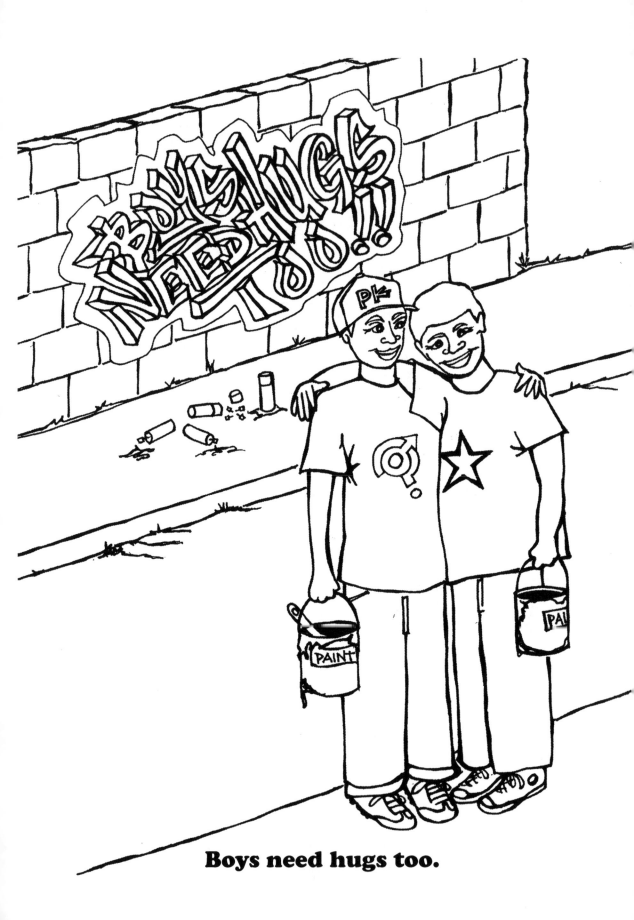

Boys need hugs too.

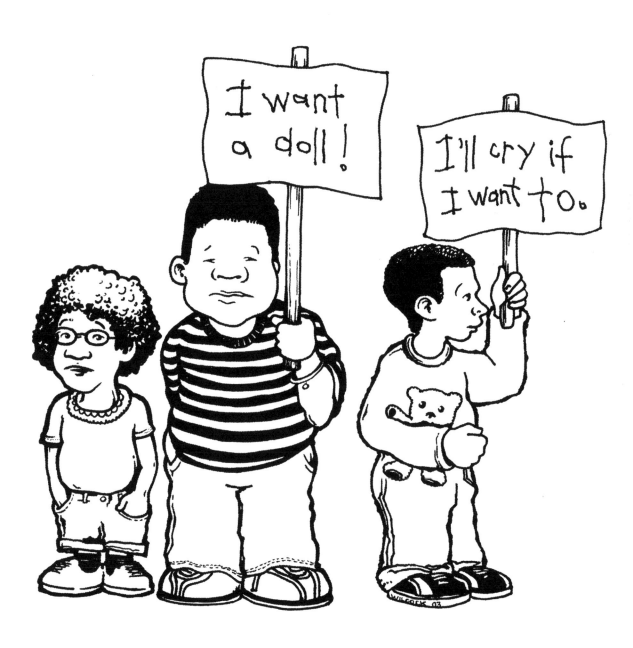

Unless things change around here, we don't want to be boys anymore.

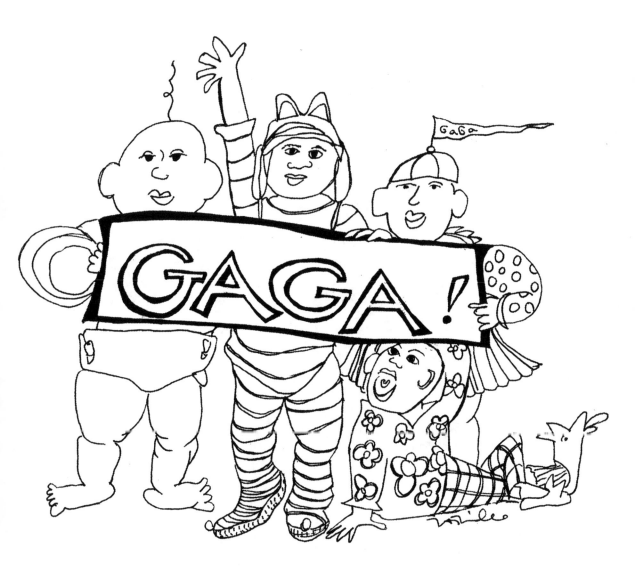

Girls Against Gender Assignment

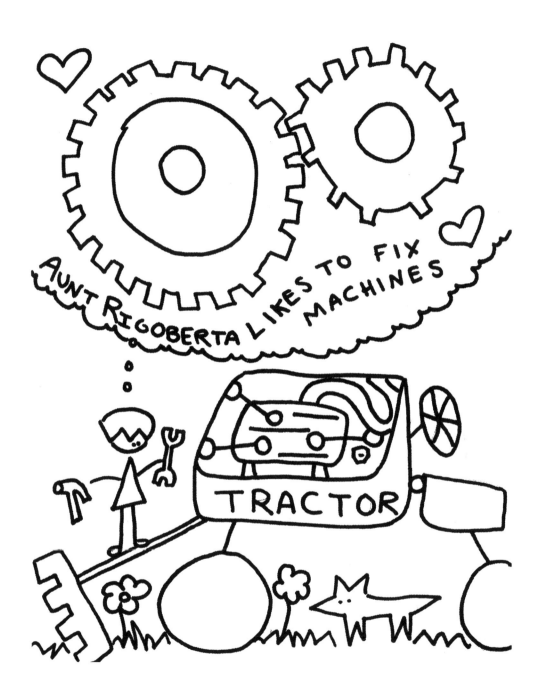

Aunt Rigoberta knows machines.

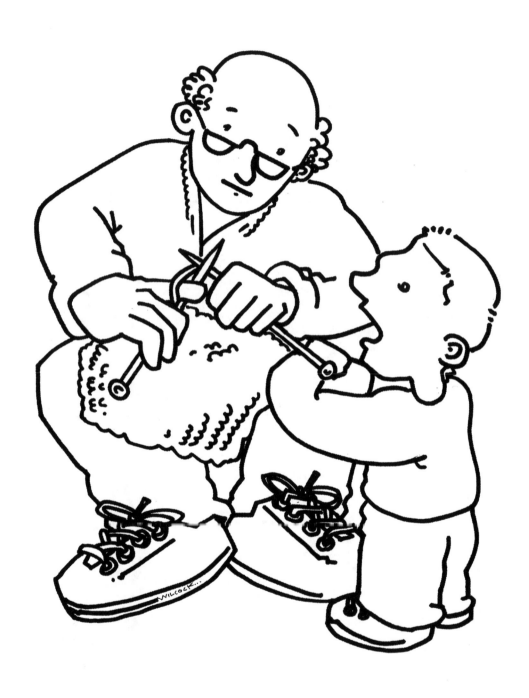

**Grandpa, when we finish knitting,
can we bake cookies?**

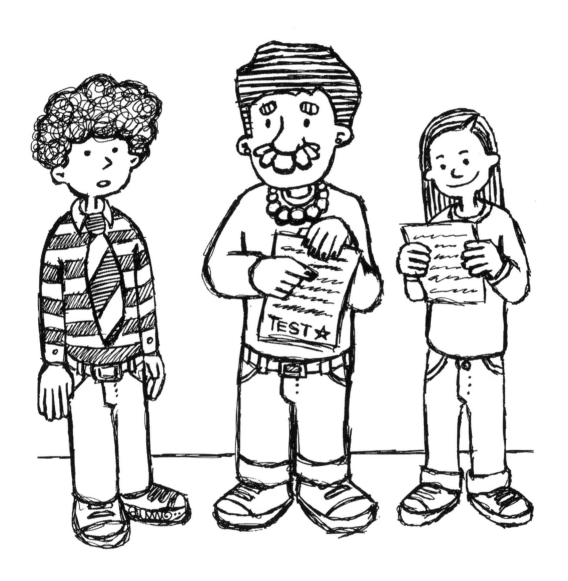

Me and my boy Tommy got 98% on our Man Tests. What did you get?

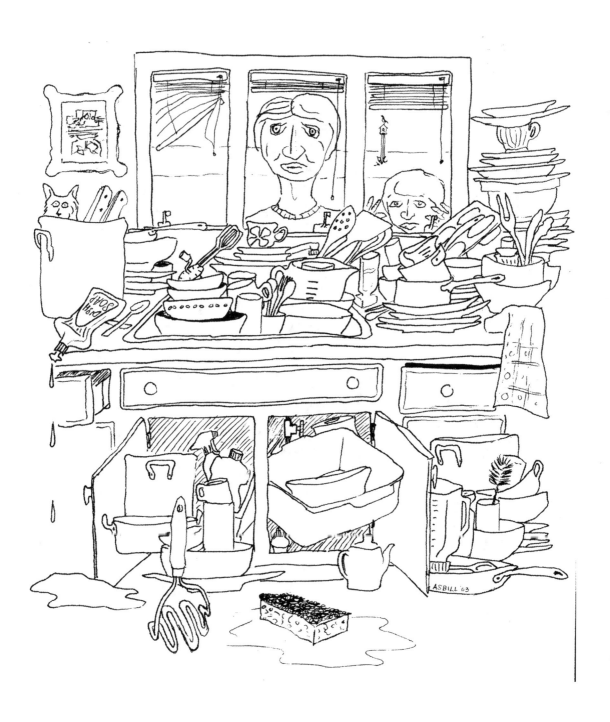

I guess mom meant it when she said she didn't want to do the dishes anymore.

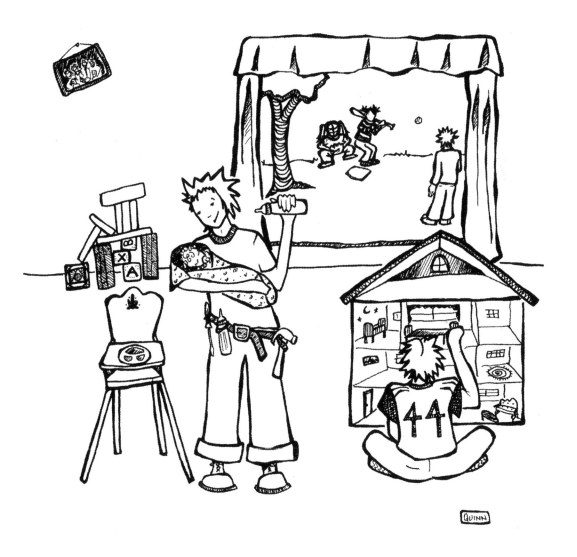

Toys have no gender.

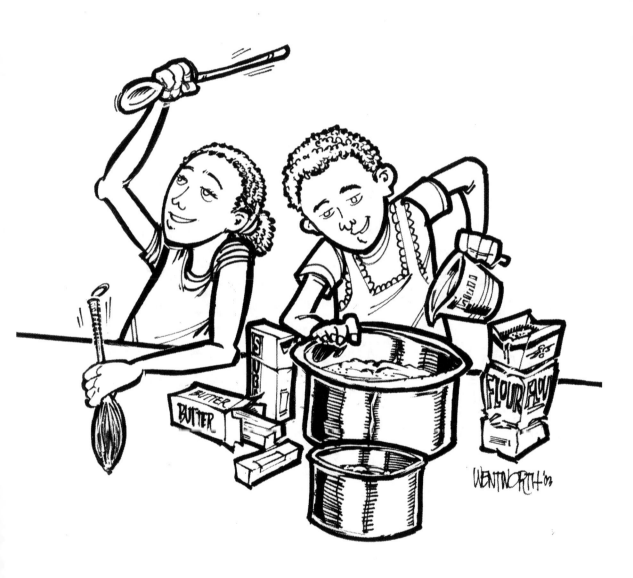

**Calvin, baking is fun and all,
but we can make a rad drum set out of these
pots and bowls.**

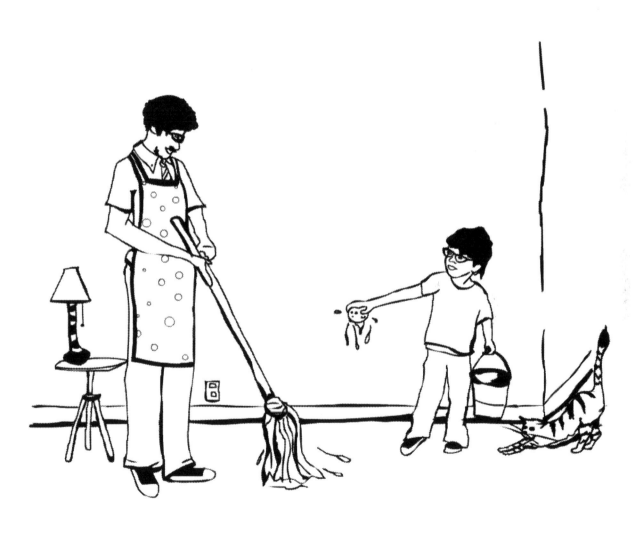

Dad, after we're done cleaning, let's go make some quiche together.

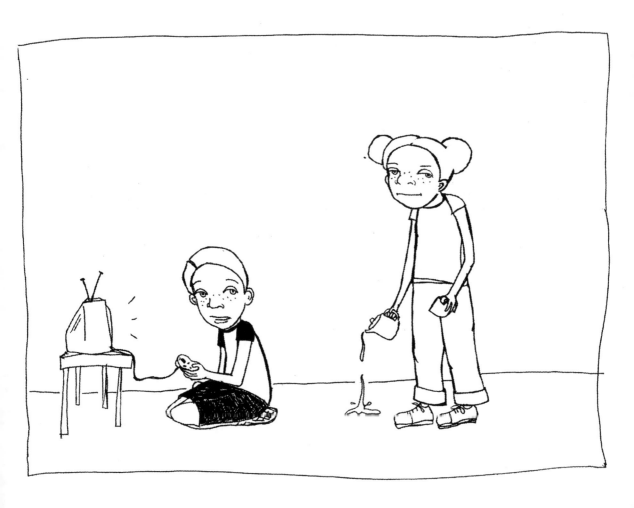

At the age of five, I decided to stop serving him.

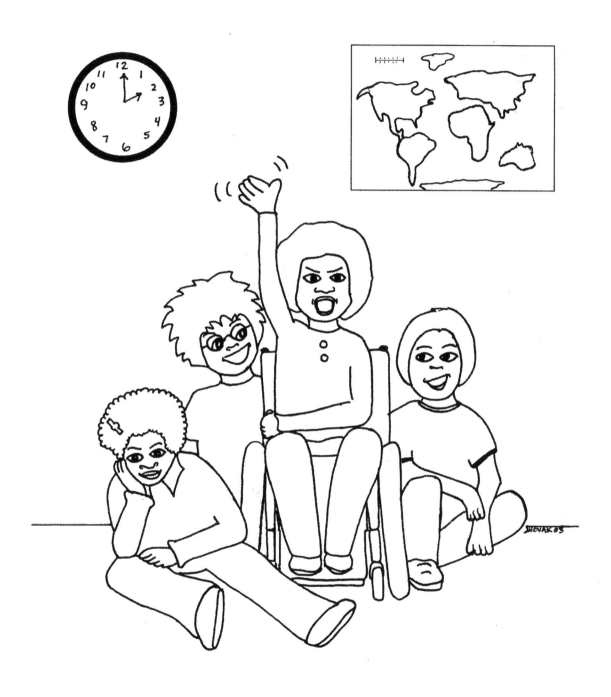

Enough about our forefathers, let's learn about some revolutionary women.

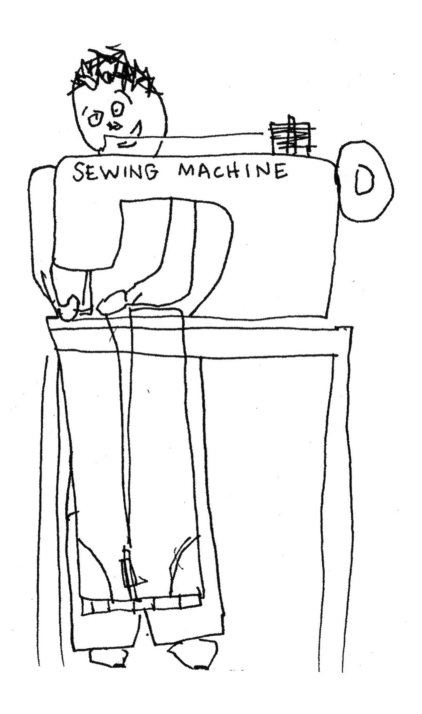

**Stanley spends Super Bowl Sunday
sewing slacks.**

**Olivia is getting ready to show the
neighborhood how to fix a flat.**

**Okay, Daisy, you try the pants and
I'll try the dress.**

Cole likes to nurture...

...and be nurtured.

I finally found the right outfit!

Don't let gender box you in.

I'm not about that, mom!

See what I mean? I wouldn't like it either!

**Sometimes the princess is saved by
the girl next door.**

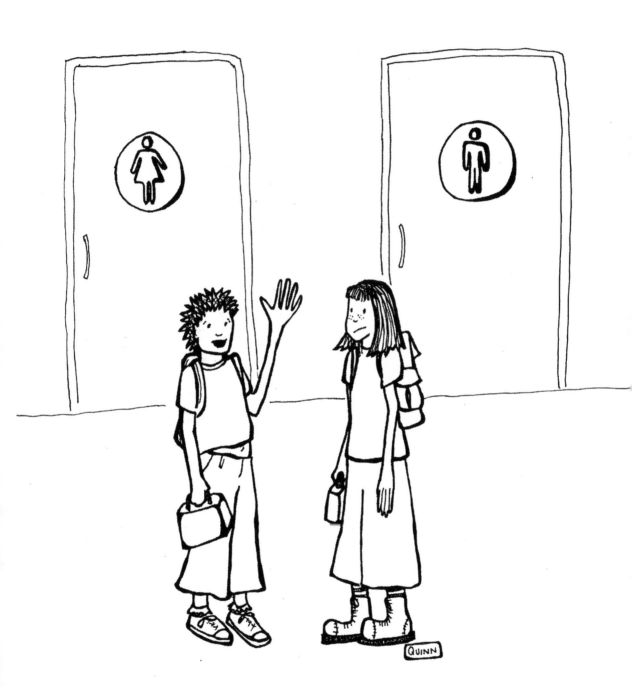

I should have worn a skirt. The pants bathroom is all full.

I never knew we had so much to choose from!

When we get together, there isn't anything we can't be!

Contributor Bios:

It is **Jacinta Bunnell's** ("I'm allowed to get angry!", "I'm not about that, mom!" and "See what I mean? I wouldn't like it either!") sincere belief that the world would be a more benevolent and meaningful place to live if everyone was encouraged to build their own drum sets and to ride skateboards; and if no one was ever ridiculed for wearing rainbow-striped stockings and painting each other's toenails at sleep-over parties. Jacinta believes we could ALL stand to cry and wrestle more. Jacinta really likes that time the Barbies and GI Joes got their voice boxes switched.

Irit Reinheimer ("Stanley spends Super Bowl Sunday sewing slacks" and "Olivia is getting ready to show the neighborhood how to fix a flat") enjoys giving crew cuts to Barbies and remolding their plastic feet so they can fit into running shoes instead of high heels, enabling them to participate in more than just beauty contests. Irit also likes dressing up in dad's suits accented by mom's make-up for family meals and special events. Every year Irit takes "Don't Ask, Don't Tell" GI Joe to the local Gay Pride March, which is one of these special events.

We all have the potential to set children's minds free. In his own life, **Shane Ballard** ("Cole likes to nurture and be nurtured") remembers adults who helped him find the road to his own liberation. He also remembers adults who tried to bind him with their own ignorance. His contribution to this book is a message to everyone who is blessed by this book's creation. That message is: be who you are. Shane can be reached at ballardshane@hotmail.com.

Quinn Tuffinuff ("Don't let gender box you in", "I should have worn a skirt. The pants bathroom is all full" and "Toys have no gender") is a storyteller, terrible accordion player, crafty thing-maker, dirt-digger, cookie-baker, sister, kid, friend and lover, who wears skirts over pants to be able to use whichever bathroom is cleaner. Mostly, Quinn whittles the days away by dreaming up radical picture books and playing acoustic folky kinds of music. Quinn can be reached at thimbleandacorn@ziplip.com.

Laura Ann Newburn ("I finally found the right outfit!") is a displaced California native residing in gay-unfriendly Virginia. She spends her time of late trying to find more creative employment so that she can leave the world of spreadsheets behind her. Her hope is to one day have something published so that she can fill her days with reading, watching cartoons and foreign films, and petitioning for the opening of a Jamba Juice within 10 miles of her house. Her work has been seen in that 'zine of 'zines *Bamboo Girl*. Laura can be reached at general_misfit@cox.net.

When he was a boy, **Marq Swerve's** ("Boys need hugs too") mom assured him that being sensitive was a good thing. But he got picked on really bad at school for crying on the playground when he got upset. This made him feel sad and lonely, so he tried hard not to cry and be sensitive around others. Then Marq and his parents and his two brothers went away to another country far away for three whole years and he had to leave his friends behind. Marq wanted to learn about his new home and make new friends so he tried to be sensitive again, but he still got picked on when he wasn't good at certain "boy" things. As he grew up Marq learned that being sensitive actually helped him make great friendships, become strong, learn new things, and even have fun! Now Marq remembers what his mom told him when he was young, and tries to be sensitive as much as he can, which he thinks is just plain fresh! Marq represents Poughkeepsie, NY, thinks Jacinta and Irit are the coolest and that someone should compile a coloring book of aerosol/graffiti art. He can be reached at ylosabes@ziplip.com

Being an in house artist/consultant throughout the conception and creation of the coloring book, **Michael Wilcock** ("Grandpa, when we finish knitting, can we bake cookies?" and "Unless things change around here, we don't want to be boys anymore") has gotten a first hand look at the genius and beauty of the great Jacinta Bunnell and is proud of Jacinta and honored to be included in these pages. Michael taught art to school kids until he decided he hated bossing kids into making art, then he made art for bosses as a freelance illustrator, and now he sticks it to the boss by playing hyperactive pop-hook rock in his two person duo The Kiss Ups and draws pictures for Jacinta on request and even sometimes when least expected. Michael can be reached at michael@thekissups.com.

Lynn Bondar ("Okay, Daisy, you try the pants and I'll try the dress") is a graphic designer who lives in Hurley, NY. Dogs and cats are her favorite playmates.

Giselle Potter ("When we get together, there isn't anything we can't be!") mostly illustrates children's books. Some of her books include *Kate and the Beanstalk* and *The Brave Little Seamstress* which are re-tellings of fairy tales with heroines rather heroes, and *The Year I Didn't Go To School* which is about her travels in Europe with her parents' puppet troupe.

Lex Lethal bikes and draws in Portland, Oregon. Lex can be reached at vendetta@hellokitty.com.

Elokin Cheung is a mixie kid—mixed gender, mixed ethnicity, all mixed up and keeps on mixin'. The world is your mixing bowl! You can combine a little bit of this gender, and a little bit of that one, or you can whip up your own kind of gender, or not choose to have one at all! We're all different, and that's what makes us a good batch. So let's break the gender molds together, and see all the fun things we can come up with. Elokin likes to work on art projects with other people, so if you have any ideas, get in touch at: Gardenkids@wildmail.com

Julie Novak ("Enough about our forefathers, let's learn about some revolutionary women.") is a musician, performance artist, visual artist and graphic designer living in New York's beautiful Hudson Valley. Recently, she completed a new coloring book with Jacinta called

Girls Are Not Chicks (check out the website: www.girlsnotchicks.com). She is currently working on recording with her band, Guitars & Hearts, in which she plays drums and sings along with guitarist Lauren Camarata and bassist Kate Walker. She is really, really happy to be part of this book. She thanks Jacinta and Irit. Julie can be jnovak24@yahoo.com.

Hopie Windle ("Girls Against Gender Assignment"), an obviously uncharacteristic Virgo, will easily admit coloring within the borders poses a challenge even as meditative therapy. But, in the same breath, coloring for Hopie is right up there with watching Oprah. In fact, coloring while watching Oprah could be as scrumptious as a chocolate sundae. Hmm, now wait a minute...She would like to thank Jacinta and Irit for providing a healthy alternative to the cartoon figure sticker books, wet in the color coloring books that have lately become our only options. Color on! Fer festivus! Hopie can be reached at hopewindle@earthlink.net.

Kristine Virsis ("We'll decide for ourselves what girls can be") loves pajamas, vegan doughnuts, sleeping and wearing scarves indoors. When she goes to school she enjoys taking pictures of stuff and learning about glaciers. Her best friend is a toothless cat named Oliver. She likes toy cars but would pass up a real one for a ride on her bike any day.

Sarah M. Hougan ("I never knew we had so much to choose from!") is an artist in her thirties living in Northampton, MA. She grew up right in downtown Boston and is a definite "city kid." She has loved arts and crafts since she was little-teeny-tiny and now includes it as one of her professions. Working with many mediums and styles, she is excited to continue growing in art and life. Her lifetime goal is to be happy and filled with love. Sarah can be reaches at sarahdidit@attbi.net.

Nicole Georges ("At the age of five, I decided to stop serving him") is the creator of the zine *Invincible Summer*. She is a karaoke all-star and co-organizer of the Portland Zine *Symposium*. Nicole loves her dog Beija, her Hitachi Magic Wand, and teaching zine workshops to children. She currently resides in Portland, Oregon, and is often referred to as "mean" or an "aggressive femme."

Citizen Frolik (R. Wentworth) ("Calvin, baking is fun and all, but we can make a rad drum set out of these pots and bowls") draws, designs and walks around in the parks and graveyards of Malden, MA. Frolik believes gender is a spectrum, and can frequently be found in the frequencies between infrared and ultraviolet. R. can be reached at citizenfrolik@yahoo.com

Cindy Ovenrack ("Aunt Rigoberta knows machines") writes *Doris Zine*.

Amanda Burr ("Dad, after we're done cleaning, let's go make some quiche together") was hatched in a small town outside of Buffalo, New York, and lived and grew up with her surrogate cyborg family in a small town outside of Albany. Now an Art History and Painting major at SUNY New Paltz, Amanda spends the little free time she has attempting to re-

program her robotic mother to say funnier things at impeccable moments, like Screech's robot-pal, Kevin from "Saved by the Bell". Currently she lives with her small but fierce tiger cat Queemy, who specializes in facial pouncing. Amanda can be reached at palestar415@hotmail.com.

Paul Heath ("Me and my boy Tommy got 98% on our man tests. What did you get?") likes coffee and robots, both of which are gender-free. Heath is the creator of *Miss Pellings Megazine*. Paul can be reached at heathkid@hotmail.com.

Michael Asbill ("I guess mom meant it when she said she didn't want to do the dishes anymore") is an artist with many different interests. He has been a teacher, a cook, a construction worker, and a research assistant at a dinosaur dig. He is presently renovating a house in an old children's camp in Mettacahonts, New York. Micheal can be reached at michaelasbill@yahoo.com.

Acknowledgements:

Thanks to all of our fabulously beloved friends in the Hudson Valley who inspire and encourage us. To Tea and Crumpets for nights of laughter, crying, and camaraderie. To Jon who put the finishing touches on the first version of this project with creative instinct and care. To Michael for giving us a home in which to create this project as well as all his love and support. To Rafter and Maxwell, who gave us a super helpful and much appreciated push when we needed it. To Amy and Annia, who sat with us while we worked things out.

To Bob and Chris at Canal Press, our marvelous local print shop in Rosendale, NY. To all of the artists who contributed their work, creative ideas and hearts to this book. To the young people in our lives, who show us how to be brave and challenge us with their mere presence. To our families, who inspire our rebellion. And to each other for our commitment to friendship above all.

Printed in the United States
by Baker & Taylor Publisher Services